The Official

COUCH POTATO™

HANDBOOK

A Note About This Book

This handbook has been written with the loyal Television viewer in mind. Each section is short enough to be read during brief intervals—commercials, pledge breaks, presidential press conferences, and so forth. In fact, that is how this book got written.

Allowing sufficient time for food breaks and rest periods, an average Couch Potato will still be able to get through this handbook in less than a week or two.

—EDITOR

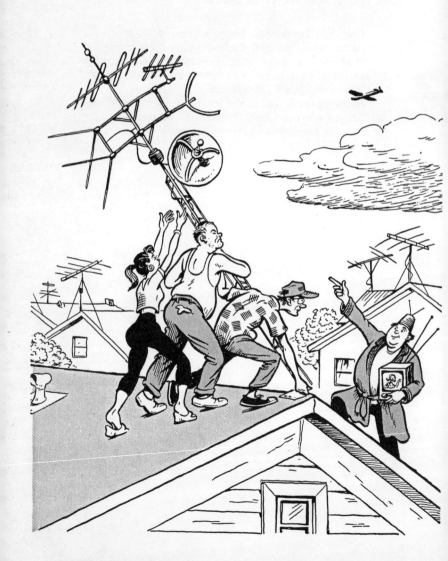

The Official

COUCH POTATO®

HANDBOOK

A Guide to Prolonged Television Viewing

Jack Mingo

Illustrated by Robert Armstrong

LAST GASP
San Francisco
1988

Typography and design by Patricia Graves.

Printed in the United States of America.

Library of Congress Catalog Number: 88-081122

ISBN 0-86719-358-1
ISBN 0-86719-370-0

Published by: Last Gasp
 2180 Bryant
 San Francisco, CA 94110

Contents

Introduction

THE OFFICIAL COUCH POTATO HANDBOOK takes up where your *TV Guide* leaves off. It will help you to get more out of your Television viewing experience by improving your viewing ability, increasing your stamina and keeping you in top shape by revealing for the first time in book form the secrets of the Couch Potatoes. It will make you a better and happier person, free from guilt for spending hours, days (and for some, even weeks) in front of your Television.

Persecuted by those who would have us believe that Prolonged Television Viewing is harmful—even sinful!—Couch Potatoes have long been forced to live underground, practicing our esoteric art alone or in pairs. Only rarely, and under the constant threat of ridicule from the outside world, could groups of three or more Couch Potatoes commune in sacred Simulviewing sessions.

Until now.

In our country today, where there are more homes with Television than with indoor plumbing, where Ronald McDonald is more readily recognized than Ronald Reagan, our Prime Time is at hand. Now is the time for Couch Potatoes everywhere to lie down and be counted! To come out of the closet and view with dignity!

The Recline of Western Civilization has begun!

—J.M.

"Television is not a substitute for reality, but is itself an immediate reality."

—MARSHALL MC LUHAN

"Television is the greatest single power in the hands of mortal man."

—LE ROY COLLINS

"We are human and, given a chance, we still might create an art form of Television."

—GILBERT SELDES

What is a Couch Potato?

The first public demonstration of high-definition electronic Television took place on a momentous day in 1935. The first recorded case of Television Guilt was discovered three days later, at a party, where one Edward R. Zorn of Bridgeport, who had watched every minute of the demonstration, announced loudly, "Television? I don't watch it. It's for morons, you know. A waste of time."

For many years, that was the status of Television viewing in most quarters: guilty, secretive viewers watching TV in private while denouncing it in public. Even in the 1960s, when women, gays and other stigmatized groups came out of the closet, Television viewing was still a dirty little secret for millions.

Out of this soil of repression and scorn the first Couch Potatoes sprung. "Why feel guilty?" they asked. "There's no reason to be ashamed. Say it loud: 'I'm a TV viewer and proud!' "

But spending the better part of their lives in front of the Tube means more to these dedicated viewers than working up a good "video tan." To a true Couch Potato, Prolonged Television Viewing is a way of life.

TV in our time has become all-pervasive. Its influence touches billions. The Couch Potatoes recognize the profound importance of this medium, and spend as much time as possible basking in its blue light. While the rest of the world rushes madly in endless pursuit of excitement and meaning in life, the Couch Potatoes are at peace. "Art may imitate life," they say, "but life imitates Television." All of life's secrets, members believe, can be discovered right in their own living rooms. They can become worldly—vicariously, and without undue exertion—through the magic of TV programming. And naturally, this experience is enhanced by the practice of one or more of the many Couch Potato disciplines, such as Simulviewing, in which the viewer's perceptions are elevated to their peak by watching five or more programs simultaneously; or by the Zen-influenced practice of Transcendental Vegetation.

The Name Explained

What better symbol for an organization dedicated to the pursuit of Inner Peace through Prolonged Television Viewing than the noble spud? Like its namesakes, the potato is a Tuber. It is the essence of vegetation. It is *covered* with eyes.

The name came to an early Couch Potato Elder

in a cosmic revelation — one of many such documented "experiences" induced by Prolonged TV Viewing. The irony of Couch Potatoes being forced to live underground in the early days of the movement has been interpreted by the Elders as a sign of Divine approval.

The Couch Tomatoes

The Couch Tomatoes began as the Couch Potatoes' women's auxiliary group, back when it was thought that women were incapable of the perfect viewing experience. Couch Tomatoes would participate in Couch Potato gatherings by fetching, adjusting and changing the channels.

All that changed, though, with the beginning of the Equal Rights to the Couch (ERC) Movement. Today, women are recognized as equal couchmates by all but a few recalcitrant Couch Potatoes. Many women now apply to the ranks of the Couch Potatoes — and none have been turned away — but others still become Couch Tomatoes as a symbol of pride in their heritage.

Are You a Couch Potato?

The Seven Warning Signs

Many devoted Television viewers are so conditioned by guilt and social censure that they deny the truth—even to themselves.

To help self-denying excessive viewers face up to reality, the Couch Potatoes have compiled a list of diagnostic questions about your TV viewing habits. Answer these truthfully:

1 Are moments spent in front of the Tube some of your fondest childhood memories?

2 Do the people on TV seem more real to you than your friends and family?

3 Are you the only person you know who can sing the entire *Gilligan's Island* theme song?

4 Do you ever lie about how much Television you watch?

5 Do you ever watch more than one TV at a time?

6 Do you ever "bliss out" in front of the Television and forget what you were watching?

7 Do you ever find yourself defending *Laverne and Shirley* as "actually a pretty good show"?

If you answered "yes" to one or more of the above, congratulations. You are eligible to become an official Couch Potato.

If you answered "yes" to *all* of the above, Couch Potato Headquarters wants to hear from you immediately!

Types of Prolonged Television Viewers

Though united in their love of the flickering screen, Couch Potatoes have diverse tastes when it comes to the programming they enjoy. The organization has identified several significant sub-groups in its ranks. Here are some of them:

Soapers

One has to admire the compassion and selflessness of Soapers. Primarily Couch Tomatoes (i.e., females), Soapers empathize deeply with the characters on their favorite dramatic series, no matter how convoluted and improbable their problems may seem to others.

Soapers used to come out only during the afternoon hours, but as prime time gets progressively more "soaper-ized," they can be spotted fuming with anger or weeping uncontrollably at almost any time of day.

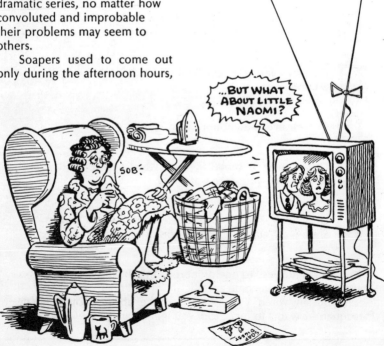

M*A*S*H Potatoes

Named after the late, great comedy series (may it re-run forever), M*A*S*H Potatoes are addicted to relatively sophisticated, intelligent and sensitive comedy shows. Most have well-developed senses of humor, and all but a few are able to recognize something funny without the assistance of a laugh track.

Spec-Taters

These "sportomorphs" are your basic drink-beer-and-watch-football-till-you-pass-out types. Many were actually athletes in younger days to whom maturity (and several knee operations) taught the lesson that it's safer, smarter and more rewarding to watch TV.

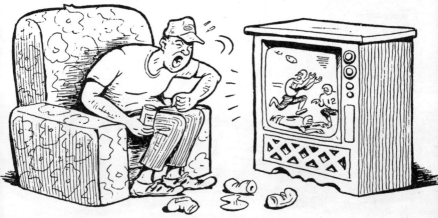

Sweet Potatoes

These sentimental viewers watch massive amounts of heartwarming programming featuring kids, dogs, loveable old folks, people in love, Christmas themes and all combinations thereof. Favorites include *The Waltons*, *Little House on the Prairie*, *Family Affair*, *Nanny and the Professor*, and *A Charlie Brown Christmas*.

Some Sweet Potatoes keep an emergency supply of insulin on hand, just in case.

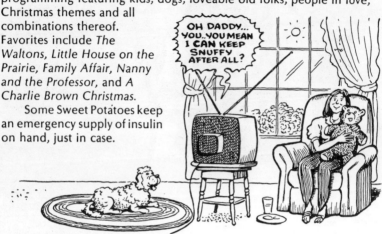

"Spud 'n' Guts" Viewers

Television Violence is the main event for this group. They keep their TVs tuned to cop shows, wrestling matches, roller derbies and hockey games. They watch auto racing to see bloody crashes, and presidential speeches in the hopes that they'll see an assassination attempt.

Spud 'n' Gutsers do not make very good friends, and one should never, *never* change the channel without asking them first.

News Potatoes

These well-informed viewers always want to know what is going on around them. They watch nothing but news reports and documentaries. As a result, they tend to be chronically anxious, cynical and suspicious of humanity. Most never leave their homes.

Red-eyed Potatoes

When the stars come out on the *Tonight Show*, these late-night viewers are just getting warmed up. Through *Letterman*, the used car ads and the *Late, Late Show*, these viewers still don't feel satiated until the end of *Farm Report*. Some are bonafide insomniacs; others only hope to develop a case of it.

Uncommon Taters

These cream-of-the-crop Couch Potatoes watch PBS almost exclusively. Some are such devoted viewers that they feel guilty if they don't promise their life's savings during pledge week.

Their heroes are William F. Buckley, Carl Sagan, Julia Child and Big Bird. Most have chronic urinary problems from waiting for commercials that never come.

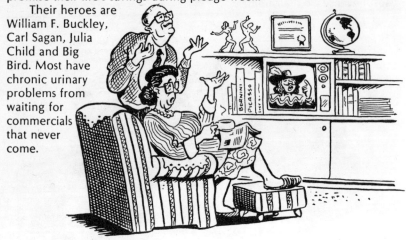

Re-Hash Browns

The largest Couch Potato sub-group, Re-Hashers watch only the old TV shows. They believe that Television, like fine wine, improves with age, so the older the program the better. Most of them are suspicious of color Television.

Fine Art Viewers

This is the newest crop to emerge from the Couch
Potato "Avant Garden." They watch
Television for aesthetic reasons. Many
have more than one set and turn them
sideways or upside down
to watch test patterns
and video snow. Some sit
three inches from the
screen for a pointillistic
effect.

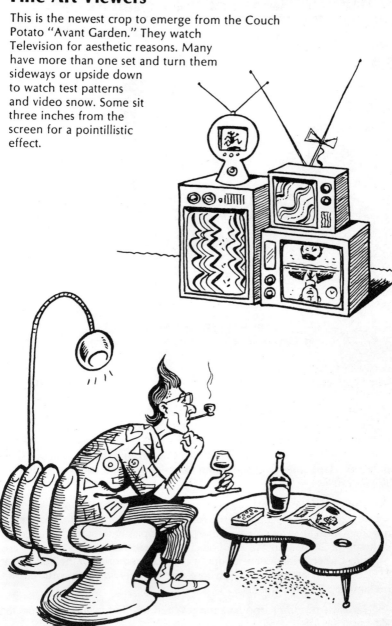

Unsung Heroes of the Couch Potatoes

PHILO T. FARNSWORTH
inventor of Television as we know it

On September 7, 1927, Farnsworth demonstrated the first all-electronic Television transmitter and receiver in San Francisco, California. Unfortunately, Farnsworth doesn't get much of the credit—his glory was stolen, along with many of his ideas, by Vladimir Zworykin from RCA. Although later court decisions finally established that Farnsworth was indeed the inventor of the all-electronic TV, Zworykin, through the backing of RCA's publicity department, is still often mistakenly cited as the "Father of Television."

The Couch Potatoes have posthumously elected Farnsworth a Couch Potato Saint and have pledged the resources of the organization to setting the story straight. A commemorative plaque is planned for the building still standing at 202 Green St., San Francisco, where Farnsworth worked. Los Angeles Couch Potatoes are planning a similar memorial for the building at 1330 N. New Hampshire Ave., where the 19-year-old Farnsworth did his preliminary TV experiments.

Farnsworth didn't stop inventing. When he died in 1971, he held 150 U.S. and 100 foreign patents.

The Couch Potato's Basic Equipment

The Television Set

The Television is a Couch Potato's best friend. Spare no expense, even if you have to scrimp on luxuries like rent, food and car payments. Remember that a Couch Potato without a Television set is just an indolent jerk staring at the wall.

What kind of TV do you need? Dependability is the most important thing to keep in mind. Remote control is also nice — why wear yourself out jumping out of the couch every half hour? In fact, automatic *everything* is best for maximum viewing pleasure, but beyond that it's a matter of personal taste.

Some Couch Potatoes actually prefer small screens to wall-sized projection units. Some would rather own one expensive color set while others would prefer to buy four or five cheap black 'n' whiters for the same price. Nostalgic Tubers swear by vintage Dumonts and RCAs, yet others wouldn't be caught dead watching anything less than the Japanese state-of-the-art, high-tech modular systems.

Try them all before you buy. Then choose the set or sets that are right for you. Remember that this is an investment that you are going to spend the next several years of your life with.

Maintaining Your TV Set

Most maintenance must be done by a trained professional. However, there are a few things you can do with a minimum of training and effort that will keep your TV set in top viewing condition:

Cleaning the Screen: No use wasting your energies until absolutely necessary. Your screen will tend to collect a layer of dust, but this isn't necessarily bad. Dust mutes the bright colors that can irritate your eyes after hours of constant viewing, and also eliminates glare from other sources of illumination.

A good rule of thumb is: Don't bother cleaning the screen until you can no longer tell whether the TV is on or off.

Put down newspapers, if you have them. If not, old *TV Guides* can be spread around the set if they're not spread around the set already. Wipe the screen with a soft cloth and window cleaner if you have them. In a pinch, a little beer and the t-shirt you wore yesterday are almost as good.

While you're at it, you might as well wipe the butter, mustard, potato chip grease, chocolate and other crud off the knobs, especially if you're having trouble reading the channel markings.

Cleaning the Cabinet: Why bother?

Adjusting the Color: If your Television doesn't have automatic color, it will always be a little off. Even *with* automatic color, people won't look very natural. Fixing it, however, is too complicated to bother with. Most shows look just fine in black and white anyway.

Adjusting the Antenna: Here's how to do it the easy way. Shout, "Sweetie (or your choice of pet names), will you come in here a second and do me a big favor ?"

Adjusting the Volume, Vertical Hold, Etc.: (See Adjusting the Antenna).

Dusting the Top of Your Television, the Easy Way: Buy a cat.

The Couch

Too many people spend their TV time in agony because they picked their couch using the wrong criteria. Who cares if it matches the other furnishings in your living room? You and your friends are going to spend your time *sitting* on it, not *looking* at it.

Try out your prospective couch before you buy. Is it long enough? It should seat your usual complement of viewers comfortably and, when you are alone, let you stretch out on it without having to bend your knees. Is it comfortable? Are there any protruding buttons or springs to cause couch sores during long hours of viewing?

Check the fabric. *Don't buy vinyl.* It feels funny and makes rude noises whenever someone moves. There are two schools of thought regarding other fabrics. The Minimal Care group says to buy a couch with a *repellent* fabric so that if you spill something you can wait until a commercial to take care of it. The No Care group, on the other hand, suggests an *absorbent* fabric so that if you spill something, you won't have to get up at all.

A good easy chair or recliner is as comfortable as any couch if you are a solitary viewer or have limited space. If you go this route, however, don't get one that vibrates or massages. It may rub you the wrong way by interfering with your TV reception. The smart Tuber will agree with McLuhan that the Medium is massage enough.

A good footrest will make your lounging complete. Hassocks are fine, but a coffee table or a large, patient dog will work just as well.

The Toaster Oven

If the TV set is a Couch Potato's best friend, the toaster oven is a close second. While the rest of the world is going microwave, Couch Potatoes cling to the old ways advocated by their food guru, Chef Aldo, the Station Break Gourmet.

Chef Aldo says microwaves are to be avoided because they are expensive and unnecessary—most Couch Potato Cuisine takes only a commercial's time anyway—and because most prolonged viewers already get more than their Recommended Adult Daily Allowance of radiation from their Televisions.

For proven toaster oven recipes, see the section on "TV Cuisine."

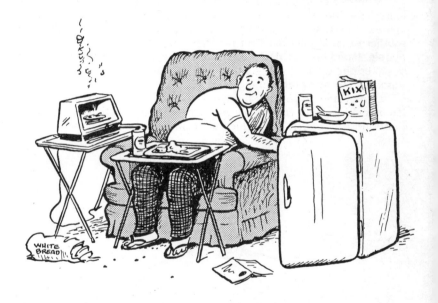

Accessories

Based on a 1000-year-old collapsing table design used by north Sahara nomads, the TV tray is arguably one of the twenty most significant reinventions of this century. No viewing environment should be without an adequate supply.

A refrigerator within reach of your couch is also a great addition. No more mad dashes to the kitchen during commercials! If you're short on space, get a small one and make it do double duty as a TV stand or coffee table. On hot days you can leave the door slightly ajar and stick your feet inside. Blessed relief and cold beer besides!

Unsung Heroes of the Couch Potatoes

GEORGE B. MUNSEY
of Little Rock, Arkansas, the inventor of the toaster oven

It all started with Munsey's marriage in 1939. His new wife asked him to prepare breakfast the first morning of their honeymoon. George agreed, not realizing he would be stuck with the job every Sunday morning (while his wife, no doubt, watched TV) until his death in the autumn of 1982.

Munsey's children used to complain to him that they didn't like the toast from the pop-up toaster. They wanted something more exotic—melted butter, gooey toppings and so forth. As George traveled the southern U.S. as sales manager for Standard Brands, he found that many people shared his kids' desire. He took a leave of absence from his job and designed the toaster oven, good for making not only horizontal toast with toppings, but many other things as well.

George and his younger brother, Lloyd, began selling toaster ovens in Little Rock, and they were so successful that the business quickly expanded into Munsey Products, Inc., which still manufactures toaster ovens today.

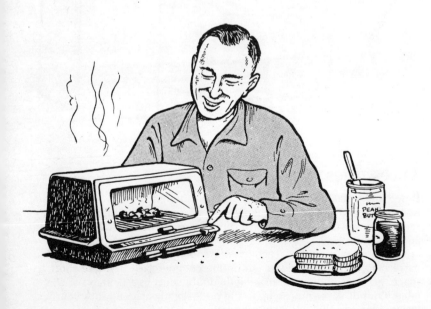

Couch Potato Fashion

Many so-called fashion experts say that one type of viewing attire is fashionable in the daytime, another during prime time, and still another for late night viewing. Some actually recommend wearing old, casual clothing during reruns!

To set this confusion straight once and for all, almost anything can be worn fashionably at a Couch Potato gathering. There are just a few basic guidelines to keep in mind.

First, never wear anything that will clash with, interfere with, or distract from what's on the Tube. Remove your hat if you are sitting in the front row. Avoid extreme hairstyles that can intrude on others' viewing space —no matter how beautiful a Beehive may be in other situations, when it blocks another's view, it's easy to wish that killer bees would take up residence in it.

Be conservative with metal jewelry. Not only can it make distracting noises, but large amounts assembled in one place can also interfere with Television reception.

Some viewers like to dress up in imitation of whatever show they're watching. A friend, for example, dons a trenchcoat and a lollipop to watch *Kojak*. This is harmless fun, but it should not go so far as to distract from the reason you're there in the first place, namely, the Television.

The Couch Potato Elders are an idiosyncratic bunch, but there is a certain amount of unanimity among them about the most comfortable and functional outfit for serious Prolonged Television Viewing. The most important part of their attire is the "Viewing Tunic" —the official Couch Potato t-shirt. It is always in style and it shows the world who you are. On top of that, many Elders wear a bathrobe, or "Lounging Jacket," and as a final touch, some don the official Couch Potato Fez. Those who have adopted this basic ensemble find that, for comfort and style, it can't be beat.

TV
FACTS
#1

☐ The word "Television" is a bastardization of the Greek *Tele*, "far" and the Latin *videre*, "to see."

☐ There are more TV sets in the United States than there are bathtubs or showers. There are more American homes with Television than with indoor plumbing.

☐ If all of the TV sets in the United States were placed end to end, they would stretch around the world more than twice.

☐ An average American living to age 65, at present levels of TV viewing, will have spent 9 years of his life watching TV. An average Couch Potato may spend more than twice as much time at it.

☐ When children, aged 4-6 years, were asked in a survey, "Which do you like better, TV or your daddy?" 54% said "TV."

Etiquette for the Couch Potato

**By Dr. Davenport H. Spudd,
Couch Potato Advice Expert**

Couch Potatoes, simply by the fact that they are already on the fringes of normal human intercourse, cannot afford to fail to maintain at least some semblance of mannered behavior. Good manners, particularly during Couch Potato gatherings, are essential, and may even be of some help in the outside world.

As is often the case with a tiny minority in this motion-crazed culture, Couch Potatoes are often in danger of ridicule and even violence. If it isn't a crazed lynch mob, it's a spouse hostile to Television, or the finance company trying to repossess your Sony. If you have mastered good TV etiquette, you may also be able to handle these affronts to your lifestyle with poise, tact and diplomacy.

Let's begin with the backbone of all Couch Potato Etiquette, the Ten Commandments.

The Ten Commandments
of Couch Potato Etiquette

I. THOU SHALT NOT have any entertainment before TV.

II. THOU SHALT NOT talk when the set is on, nor shalt thou make distracting noises.

III. THOU SHALT NOT block the vision of thy neighbor.

IV. THOU SHALT NOT interfere with the TV reception of thy neighbor.

V. THOU SHALT NOT change the channel without unanimous consent.

VI. THOU SHALT eat food that is nourishing to thy Couch Potatoism.

VII. THOU SHALT be wary of anything educational or British.

VIII. THOU SHALT buy official Couch Potato products, accepting no substitutes.

IX. THOU SHALT keep thy color lifelike, thy contrast bright and thy horizontal held.

X. THOU SHALT sit without moving, listen without ceasing and let not thine eyes wander from the flickering tube.

Now let's look at some of these points more carefully.

Commandment I means what it says. Television is its own entertainment. Couch Potatoes are not encouraged to alter their viewing experience by artificial means, such as home video games or the two-way TV systems now available in major American cities. Why watch Television if you have to think and respond? As far as I'm concerned, the main point of watching TV is that it lets you *avoid* having to do that. If you're going to have to respond to your TV, you might as well unplug it and go out and cultivate friendships or read a book or something.

—and that goes for commercials too, because true Couch Potatoes watch them with the same concentration as they watch regular programming. If you are with close friends or relatives, though, the rules might be a little looser. Nonetheless, conversation should be as brief as possible and should be restricted to the following topics:

a) Requests to pass food or drink.

b) Questions or comments of interest to all. (For instance, "Isn't that Sonny Tufts there behind the fat lady in the back of the crowd?") These should be kept to a minimum and with respect to others present. After

Commandment II has been a point of contention with some members. Fanatic, *TV Guide*-thumping Couch Potatoes (most of them "born again") claim that "Thou shalt not talk. . ." means "Thou shalt *never* talk." Others take a less literal position.

When is it okay to talk during a TV show? Almost never

all, many Couch Potatoes don't care for TV trivia. They just want to watch.

c) Unusual or extraordinary circumstances. (For example, "I meant to wait until the station break, but the building is on fire and all of us are in imminent danger. Sorry for interrupting.")

Commandment VI has raised a number of questions about food and how to serve it:

What kinds of foods are nourishing to my Couch Potatoism?

For stamina, I always recommend that you eat from all five major food groups daily: sugar, salt, grease, carbohydrates and alcohol.

Food should be as hassle-free as possible. Noisy foods should not be eaten during quiet passages. Finger foods are a good idea; not only is the clatter of silver or plasticware distracting, using utensils can be dangerous. Why risk poking yourself in the eye with a spoon, especially now that 3-D TV is possible?

For ideas on what sort of foods make the best "set-side sustenance," see Chef Aldo's section on "TV Cuisine."

What about serving food when entertaining, Dr. Spudd?

Unless you have specified that your Couch Potato gathering is to be what's called BYOFS ("bring your own face stuffing"), the host of the party is expected to supply the food. It is always in good taste, however, for guests to bring a little something with them as a token: several twelve-packs of beer, six or seven dozen doughnuts, a case of taco flavored cheese puffs, or a kilo of good weed. Unless of course it is to be a large gathering, in which case one should bring a little extra.

How much food should I plan for a normal gathering?

There's a very simple formula for that, based on the established fact that a typical Couch Potato will eat the equivalent of his or her weight in a week of video viewing. To find out how much a Couch Potato will eat in an hour, divide his or her weight by 112 (the number of waking hours in a week). Then, if you multiply that by the number of hours you have planned for your viewing session, you will know precisely how much food you will need.

As you can see, hosting Couch Potatoes can be expensive. That's why BYOFS parties have become so popular in recent years. Even more popular, of course, is never inviting anyone over.

Astute readers of the Couch Potato literature will notice that **Commandment VII** has changed slightly over time. It used to read, "Thou shalt *not watch* anything educational or British."

The Ten Commandments should be a living, changing set of rules. The change in Commandment VII reflects the improving British fare available since *Benny Hill*, and the new data indicating a lesser amount of brain damage from educational programming than previously thought.

Commandment XI is the commandment that is not yet a Commandment.

"THOU SHALT NOT infringe upon the right to a seat on the viewing couch on the basis of sex." These **19** little words have caused more controversy recently than any other Commandment.

Many Couch Tomatoes feel that this should be the Eleventh Commandment. Unfortunately, the long fight to incorporate the "Equal Rights Commandment," as it is called, has bogged down after years of battling over peripheral issues, such as should there be eleven Commandments, or which Commandment to drop if not. Anti-ERC activists are emotional and vocal. Rational debate became impossible and the issue died. ERC supporters, though, vow to continue the fight at the next International Convention and View Fest.

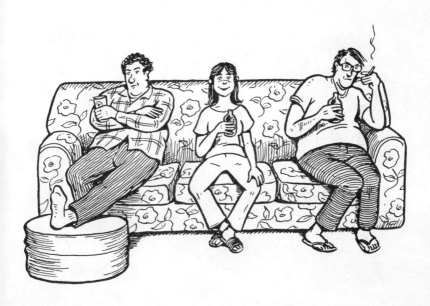

Unsung Heroes of the Couch Potatoes

THE C.A. SWANSON AND SONS CO.
the poultry company that invented the TV Dinner

The first 25 cases of TV Dinners (turkey with cornbread stuffing and gravy, buttered peas and sweet potatoes in butter and orange sauce) rolled off the line and into the stores of Omaha, Nebraska, in January, 1952. The packages featured the dinner on the screen of a miniature Television, complete with tuning dials.

The term "TV Dinner" was coined by Gilbert Swanson, chairman of the board of Swanson's Foods, while watching the Swanson-sponsored *Ted Mack's Family Hour* with friends in the autumn of 1951. One of his guests commented that it looked odd for Swanson and the others to be balancing trays on their laps so they could eat while watching TV. It reminded Swanson of the frozen dinners his company planned to market soon. Why not, he wondered aloud, call them "TV Dinners"?

History records that Swanson's guests politely ignored his outburst (he may have gotten more attention if he'd waited for a commercial), but the name stuck and the rest is history.

TV Cuisine:

Set-side Sustenance from Chef Aldo, The Station Break Gourmet

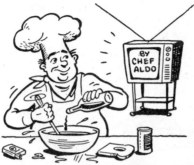

Prolonged Television Viewing requires stamina, and good eating habits are a part of every Couch Potato's discipline. Contrary to the popular image of the prolonged viewer as a prodigious consumer of prepackaged junk foods, many Couch Potatoes also enjoy the preparation and consumption of gourmet TV fare. As I always say: "Why just open a bag when you can open a couple of bags and mix 'em together?"

Pioneering Couch Potatoes didn't have it so easy. In the beginning of the TV age they were forced to rely upon whatever could be ingested via a flexible soda straw (because of the tiny screens) or prepared in the kitchen during commercials (which were fewer in those days.) Still, many favorites from the 40s and 50s, like the recipe below, greatly influenced the development of modern TV cuisine:

Little Potatoes Au Gratin

1 Can New Potatoes
¼ Chopped onion
American cheese slices
Jar Thousand Island dressing
Vinegar

Open can of New Potatoes and place under running hot water tap approximately 10 minutes. This rinses and cooks the potatoes in one step.

Chop the onion and place it in a dish of vinegar near the couchprep area. Separate cheese slices and set them to warm on a piece of tinfoil on top of the TV set. (Nowadays, you can get individually wrapped slices and leave them wrapped.)

Drain the potatoes and place them on cheese slices. Add marinated onions and wrap cheese carefully around the potatoes.

Skewer with fork and dip into jar of Thousand Island dressing. Other dressings and dips make tasty variations!

It was not until the 1950s, and the dual development of the Swanson TV Dinner and the Munsey Toaster Oven, that modern TV cuisine became a possibility and the shift began in the American family from the traditional kitchen to the hub of the modern household, the viewing module. Great innovations followed: frozen foods of all kinds, Cheez Whiz, Kool-Aid, Jiffy Pop and Kellogg's Pop Tarts were but a few culinary milestones in the Couch Potato "nouvelle cuisine." This was the era of the great media chefs, Chef Milani and the great Boy-Ar-Dee, who blazed the trail, and in whose footsteps I humbly follow.

Today a Couch Potato's diet can be as wholesome, varied and exciting as what we watch on TV. Does this mean I'm against all so-called convenience foods? *Au gratin, mon amigo, non, non!* Junk food is terrific, but variety is the spice of life!

TV cuisine is quick and convenient. You don't have to leave your set at all, and your preparation time is as brief as a commercial. It's quiet—no noisy pots, pans and silverware to disturb fellow viewers. It is high in calories and carbohydrates for stamina. There's usually nothing to clean up, and, best of all, it's delicious!

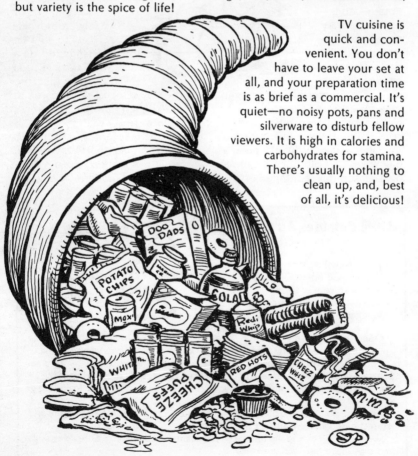

Getting Started

Every viewing module requires only a few basic tools and condiments. These include:

- Toaster Oven
- Refrigerator
- Can Opener
- Pair of Scissors
- Pickle Fork
- *TV Guide* (Tells you what's on, doubles as an oven mitt.)
- Salt, Pepper, Spices

- Aerosol cheese food or Cheez Whiz
- Squeeze Parkay Margarine
- Squeeze Hershey's Chocolate
- Squeeze Ketchup and Mustard
- Squeeze Soy Sauce
- Squeeze Lemon Juice

(Squeeze food products are one of the greatest byproducts of the space program. They have become so important in my TV recipes that I call the art of cooking with them *Squeezine*.)

Now we're ready to cook, so let's try some appetizing, TV-tested recipes.

Swiss Toast

1 Loaf generic white bread
Squeeze Parkay Margarine
Squeeze Hershey's Chocolate

Saturate bread slices with margarine. Cover heavily with chocolate and pop into toaster oven for 3 to 5 minutes, or until chocolate is runny.

Here's one that'll keep you bright-eyed for *SCTV* re-runs!

Coffee Crystal Sandwich

1 Loaf generic white bread
Squeeze Parkay Margarine
Jar Folger's Coffee Crystals

Saturate bread slices with margarine. Sprinkle heavily with coffee crystals and pop into toaster oven for 3-5 minutes. Add sugar and Cremora if desired.

A tasty variation is the "South Sea Sandwich" — great for watching *Hawaii 5-O* or *Magnum P.I.* Follow the recipe, only replace coffee crystals with pineapple chunks and shredded coconut.

Squeezine Pepper Toast

1 Pepperoncini (from the bottle)
1 Slice generic white bread, crust trimmed off

Squeeze Parkay Margarine
Aerosol can cheese food

Take medium to large pepperoncini. Snip off end at stem with scissors. Squeeze juice back into bottle.

Place nozzle of cheese product into opening of pepperoncini and fill to capacity.

Place stuffed pepperoncini into trimmed white bread. Sprinkle liberally with margarine, applying thickly to edges of bread. Fold bread over pepperoncini and pinch edges shut, as you would conventional pie crust.

Pop into toaster oven and bake to desired crispness.

A TV treat from south of the border!

Quesadilla Mole
(Mexican Chocolate Sandwich)

Package corn tortillas
Chocolate candy bars

The candy bars used in this recipe are a matter of personal choice, but I recommend the Three Musketeers bar for several reasons. For the money, you get 64 grams, compared to an average size bar at the same price. The light whipped center responds nicely to the toaster oven, and the result is a delicious soufflé analogue. There are several other interesting bars on the market, but I recommend starting with nougats or conventional chocolate bars.

Slice candy bars lengthwise into two or three strips. Place them on a tortilla and place in toaster oven set at 350°. Bake until melted.

Remove from heat. Roll up. Onions and salsa may be added according to taste. Serve on paper towel, napkin or page of an old *TV Guide*.

For those special desserts served anytime.

Little Chocolate Doughnuts

1 Box Cheerios
1 8-oz. bag chocolate chips

Pour a single layer of Cheerios on old pie tin or toaster oven pan. Carefully place a chocolate chip upside-down in the hole of each Cheerio. Pop into toaster oven and melt lightly.

Variations: Sprinkle coconut or colored sugar on chocolate after melting. For variety, try butterscotch chips.

Now that you've mastered these, we're ready to move on to more advanced cooking techniques.

Cooking With Power Tools

Many Couch Potatoes have power tools sitting around their homes they never use. Almost all of them, with a little imagination, can be adapted for food preparation. Take a household power drill, poke the bit through the plastic lid of a 15 oz. styrofoam cup, and voila! you've got a blender that's ideal for high-speed whipping. A jigsaw is great for slicing and dicing. A good belt sander will peel potatoes in a jiffy. And a butane torch is perfect for those Pop Tarts flambé.

CAUTION: Power tool cooking should be attempted only if tools are properly shielded and grounded. Wear safety lenses. Some power tools will interfere with TV reception, so confine preparation to commercials only. Power tool cooking is NOT recommended for bathtub viewers.

Here are three of my favorite power tool recipes:

Cheese Chocdog

1 Package hot dogs
1 Loaf generic white bread
1 Can aerosol cheese product

Squeeze Hershey's Chocolate
Electric Drill with ¼" bit
Safety Lenses

Put on safety lenses. Hold unopened package of hot dogs with ends pointing towards you. Leaving ends exposed, wrap several layers of old *TV Guides* around package (for safety).

Using slow speed, carefully drill each hot dog lengthwise. Open package and remove hot dogs. Fill cavities with aerosol cheese product.

Place hot dog on slice of white bread. Pinch bread into a trough around the hot dog and squirt liberally with chocolate syrup. Pop in toaster oven for 10-12 minutes, or until cheese is runny.

"Tube" Steak Paté

This is the award-winning recipe in the 1982 Chef Aldo International Couch Potato Bake Off, submitted by Ric Lawson from northern California. I highly recommend it for its near-European sensibility.

1 Oscar Mayer all-meat hot dog
2 Green olives, pimentos left in
Mayonnaise
Blender (hand drill and styro cup do not work well with this recipe)

1 Tsp. sweet pickle relish
2 Four-square saltine crackers
Pepper

Rev blender up to full speed and drop in hot dog. Add relish and olives and let blend at high speed for one-and-a-half thirty-second commercials.

Spread the saltine crackers generously with mayonnaise and break into eight squares. Spread paté on crackers and add pepper to taste. Makes 8 servings.

Extra Sharp Carrot Cake

This extra-easy version of the old favorite is almost indistinguishable from traditional recipes (the cola and spices even turn the Bisquick a rich, golden brown color). You can double the recipe and use a regular size aluminum pie tin.

2-3 Skinny carrots
¾ Handful brown sugar
1 Can generic cola
1 Pot pie tin

1 Handful Bisquick
½ Handful pumpkin pie spices
(available pre-mixed)
Electric pencil sharpener

Shred carrots in clean pencil sharpener. Line bottom of pot pie tin with carrot shavings. Add Bisquik, sugar and spices.

Knead slowly with hands, adding a small amount of the cola. Continue to knead and add cola until batter is the consistency of fresh Pla-Doh. Adjust sugar and spices to taste.

Bake in toaster oven at 400° for 15-22 minutes. Remove from oven. When cool, carrot cake can be frosted with canned or aerosol frosting.

Your TV fare need never be dull again. Invent your own recipes and send them to me, c/o Couch Potato Headquarters. Use your imagination, and in the words of my mentor, Chef Boy-Ar-Dee, "It'sa nice!"

TV
FACTS
#2

Ever wonder why there is no Channel 1 on your Television set? The FCC took the frequency away from TV broadcasters in May, 1948 for use by the military.

The first full-length movie shown on American TV was *The Heart of New York*. It was about the inventors of the washing machine.

The world's first "laugh track" was used on the *Hank McCune Show* (Saturdays, 7 PM on NBC, 1950).

27 million people watched the first televised presidential inauguration of Dwight Eisenhower on January 20, 1953. It was upstaged in the ratings, though, the night before, when 44 million people tuned in for the birth of "Little Ricky" Ricardo on *I Love Lucy*.

The first TV advertisement cost the sponsor, Bulova watches, $9.00. It was broadcast on WNBT, New York, in 1941.

How to Pick Up Couch Tomatoes

NOTE: The author, like many Couch Potatoes, was raised by the "electronic babysitter" in the 1950s and 1960s—an era when, on Television at least, men were men and women were kitchen appliances. This section, consequently, is addressed to Mr. Potato on the make for Ms. Tomato; but it is acknowledged that times have changed, and often the tube is on the other shelf these days. This advice, therefore, is offered to TV addicts of any sex, on the make for anyone, or anything.

The most difficult part of getting to know Couch Tomatoes is finding them. The obvious places are no good. Bars, for example, aren't very rewarding because the Televisions are usually tuned to some gruesome sporting event or another, and it's a rare Couch Tomato that really enjoys *Championship Wrestling*. (Find her and you're a lucky man!) Most bars are too noisy for serious TV viewers anyway, so save your polyester viewing tunic for another occasion. *Real* Couch Tomatoes, the kind you want to meet, are probably at home glued to *Knots Landing*.

That's the problem. But eventually, every Couch Tomato has to leave her Television briefly to venture out into the world. Learn to recognize the subtle clues she gives off in public. Then, with the right approach, and a little luck, you'll have no trouble getting her onto your couch for a little "je t'aime view."

In Department Stores

Go to the appliance department of any large store and you'll find dozens of Couch Tomatoes, staring slack-jawed at row upon row of brand new TV sets. Whether tuned to the same channel, like a sheet of animated postage stamps, or to different channels, like a video crazy quilt, this experience is the closest thing to heaven many Tubers will ever get.

Watch the face of the Tomato you'd like to get to know better. When it's filled with near-religious ecstasy, sidle up and whisper, "I've got eleven TVs and a designer futon at home. Want to come over and learn some new Simulviewing techniques?"

Food Shopping

Watch your step here. It's easy to be misled because many non-Tubers buy *TV Guide* and large quantities of junk food too. But only a bonafide Couch Tomato will be drawn irresistibly to the video monitor of the closed-circuit security system. Her reverie may only last a few minutes, but while in this state she's very susceptible to suggestion and will often respond to a clever opening line if you can get her attention. Jump into camera range and talk to her from the TV screen for maximum effect.

While Traveling

Even Couch Potatoes have to travel at times, despite a natural aversion to it (the terrors of unfamiliar programming schedules are not to be reckoned with lightly). If you are traveling, or just want to meet Couch Tomatoes from out of town, coin-operated TV chairs in airports and bus stations are ideal locations.

Get yourself a pocketful of quarters, pick out a likely looking prospect and wait. Almost invariably, the timer on the TV chair will run out just before the end of the program she is watching. Since any true Couch Tomato will have already stuffed all her change into the machine as a matter of course, she will panic.

That's your chance to play knight in shining armor. Step forward calmly but quickly with coin in hand. With a flourish and a slight bow, insert it into the coin box. Her immediate and undying gratitude is assured, but wave it off for the time being. Wait for the commercial to make your move.

At All Times

Carry a battery-operated portable with you. You'll attract Couch Tomatoes wherever you go: on the beach, in elevators, on buses, in wilderness areas, on city streets. You can be the Tuber of the Hour during power failures and natural disasters!

Seven Great Opening Lines
for
Picking Up Couch Tomatoes

1 "What's a nice girl like you viewing in a place like this?"

2 "Great perfume. Is that 'Channel No. 5'?"

3 "It's just an intimate little affair, but Chef Aldo's doing the catering."

4 "I was just on my way home. I've got a satellite dish and you wouldn't believe what Johnny and Ed do during commercials."

5 "UHF or VHF?"

6 "Seen any good commercials lately?"

7 "Do you want to come up to my apartment and see my 26-inch Zenith?"

TV and Sex

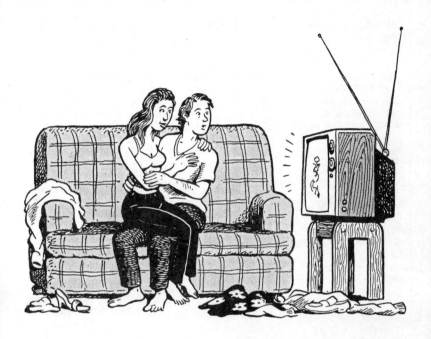

Do TV and sex mix? Well, as one woman says, "If we don't do it with the TV going, we don't do it."

A healthy sex life with Television is possible, but among Couch Potatoes, the consensus is summed up in the popular bumpersticker:

COUCH POTATOES DON'T
DO IT—
THEY'D RATHER WATCH

The logic is simple: if something interesting should come on in the middle of a romantic encounter, the distraction might result in serious injury to yourself or to your partner, or both.

Even worse, you might miss something on Television. Something you might regret for the rest of your life.

So mixing sex and TV is not recommended. Give one up. It shouldn't be too hard—sex is overrated anyway.

TV and Drugs

"Avoid buying anything that isn't advertised on Television," suggest the Couch Potato Consumer Products experts. This advice is particularly apt when considering chemically altering your consciousness for the Viewing Experience.

Tobacco

Tobacco is known to impair visibility and can be a serious fire hazard. Its use has not been recommended since January 1, 1971, when all cigarette ads were taken off Television. However, many Couch Potatoes still swear by "a little pinch between the cheek and gum."

Alcohol

This is a favorite among Couch Potatoes and is considered one of the five basic food groups for nutrition and stamina during Prolonged TV Viewing. Nationally advertised beers, wines and sherries are most heavily consumed, and Viewmeister, the Couch Potato house brew, is a favorite.

Stimulants

Most serious TV viewers avoid all stimulants but caffeine. Cocaine is too expensive and amphetamines make people want to babble uncontrollably—a violation of the Second Commandment of Couch Potato Etiquette.

Caffeine, on the other hand, is so popular among the Red-eyed Couch Potatoes that there is strong pressure to acknowledge it as the sixth major food group. Whether you get your dose from Mountain Dew or Chef Aldo's Coffee Crystal Sandwiches, caffeine will improve your viewing experience, especially if balanced by a comparable amount of alcohol.

Depressants

Depressants are not recommended for Prolonged Viewing; however, one might find it a little easier to get through an evening of network sitcoms with a slight buzz.

As for shooting drugs, don't do it. As the Spec-Taters are fond of saying, "The only dope worth shooting is Howard Cossell."

Marijuana

Marijuana has been known to enhance the TV Experience greatly—under the right conditions. It has also been known to induce the illusion that the characters on Television are just people pretending to be policemen, army field surgeons, unwed mothers and so forth, so discretion is advised.

Psychedelics

Turn on, tune in, veg out? A few Couch Potatoes have reported heightened viewing experiences under the influence of psychedelic drugs, but the hazards cannot be overemphasized. Acute cases of paranoia have been reported while watching *Dragnet*, for example.

Some claim that you can achieve Enlightenment with these chemical substances, but most Couch Potatoes believe that Enlightenment is better achieved with the "Plug-In Drug" alone.

Prolonged Television Viewing and the Human Body

When the effects of Television are discussed, it is most often the psychological effects that are stressed. Yet there are a number of physical effects related to Prolonged Television Viewing as well.

Physical Benefits

Television reduces stress—one of our Number One killers. Stress has been directly related to hypertension, ulcers, cardiovascular disease, asthma, tooth decay, female problems, arthritis, even cancer. Television is a safe, effective aid to reducing stress, and it's available without a prescription.

Safety is another significant benefit of TV. Let's face it, it's dangerous to leave your home. Studies make that clear. Virtually all auto accidents happen outside the home. The cities are full of muggers, psychopaths and murderers. In the country there are snakes, poisonous plants and deadly cancer-causing rays from the sun. By contrast, TV viewing is one of the safest activities imaginable—so safe, in fact, that many insurance companies are considering offering lower rates to practicing Couch Potatoes (see your agent for details).

Television has not been around long enough for definitive longevity studies, but it may be that TV not only helps you to live a better life, but a longer one as well.

Physical Dangers

There are several problems related to Prolonged Television Viewing as well, though their effects are far outweighed by the physical benefits discussed above. Some of the more common maladies affecting Couch Potatoes are:

Eyestrain
A frequent complaint. If your couch is becoming a site for sore eyes, it doesn't mean you're watching too much Television. Eyestrain can be reduced significantly with proper lighting, larger picture tubes, or the practice of Closed-Eye Viewing, which is being taught nationwide by trained Couch Potato experts.

Tooth Decay and Obesity
The Couch Potato diet has been attacked by misguided nutrition "experts" for years now as a cause of both tooth decay and obesity. Couch Potatoes, however, have on the average no greater incidence of either affliction than the general population. Some Couch Potatoes, in fact have *reduced* tooth decay by following Chef Aldo's suggestion of squirting small decorative spots of Aquafresh toothpaste on all their TV snacks.

Obesity, on the other hand, is in the eye of the beholder. Many Couch Potatoes feel that their bottom-heavy girth is the ballast that keeps them from falling off the couch. Weight-conscious Tubers have adopted a vigorous routine of Tele-Cise®, described below.

Suzanne Sommers Whiplash
A problem that frequently strikes neophyte Simulviewers. Among Couch Tomatoes, it is known as **Tom Selleck Whiplash.** It happens when watching several TV programs at once. The neophyte, concentrating on just one screen, is suddenly distracted when someone shouts, "Look! Suzanne Sommers doing jumping jacks on Set 1!" He jerks his head in that direction. A sharp pain shoots through his neck. He is a victim of his own inexperience, which only patience and practice will cure.

Couch Sores
Couch sores are similar to the bed sores hospital patients suffer occasionally. The solution is the same, too: change your lounging position at least once every six to eight hours.

Tele-Cise®:

Toning Up While Tuning In

**By Arlene LaBunche,
Couch Tomato Health and Beauty Expert**

Many of you Couch Potatoes think that eating a lot and drinking caffeinated soft drinks is all you need to stay in shape. But if you expect to endure the rigors of marathon viewing, you have simply got to exercise!

Tele-Cise® is an applied program of bathrobics and eyesometrics designed by experts for painless exercise in front of the Television. If practiced properly, it will bring out the ideal Couch Potato physique, with just a few extra pounds of "potential energy" (fat) distributed below the navel to provide padding to the derriere and thighs for protracted sitting.

Here are some of the most popular Tele-Cise® routines. Everybody ready? Turn on that TV and LET'S EXERCISE!

The Toaster Oven Stretch

This works with the set-side refrigerator too. Sit a few feet away from your toaster oven so that every time you reach for more food, your arm and shoulders get a strenuous workout. Be careful not to strain your back!

The Five Beer Bathroom Dash

Drink a lot of beer. Wait awhile. At the next commercial, amble semi-quickly to the bathroom, do your duty, and amble back before the program resumes. If you are watching Television with other people and have only one bathroom, the Five Beer Dash makes for an exciting competitive sport.

The TV Triathlon

This exercise is actually three in one. When you get up to adjust the set or change the channel, do the following in semi-rapid succession:

a) *The Wonder Woman Spin.* Put out your arms and spin around several times like Diana Prince when she turns into Wonder Woman. Chances are you won't turn into Wonder Woman, but if you do, you can skip the following steps.

b) *The Dick Van Dyke Hassock Hop.* Head toward the nearest hassock and, at the last second, attempt to sidestep it gracefully while still dizzy from event A. About 50% of the time you will misjudge the distance and end up doing the classic Van Dyke pratfall. Get up and go on to the next event.

c) *The $6 Million Man Run.* Cover the remaining distance to your TV set by running in slow motion. Try to run as slowly as possible. Make the adjustment and then "run" back to your place on the couch (beware that hassock!) and settle back to rest. Replenish your vital fluids with several tall beers—you deserve it!

The "Hassock It To Me"

Here's an exercise Couch Tomatoes can do with their mates to firm up those soft bottoms and help eliminate those dreaded cellulite saddlebags:

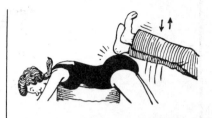

Flex cheeks, roll heels into buttocks, knead buttocks with heels.

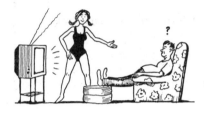

To start off, make sure your Potato is sitting relaxed and comfy in that large armchair, with snacks at fingertips, and eyes in good viewing range. Hassock should be positioned under his extended feet.

Now arch back, tighten cheeks, head up for viewing position. Releases hostility and frustration while viewing.

Now, without disturbing the field of vision, position yourself on the hassock with posterior under viewer's large feet.

Do 1,000 butt flexes with foot pounding every day for a more boingy bottom! Eventually female can replace hassock.

TV
FACTS
#3

☐ Huey "Kingfish" Long, Governor of Louisiana, took his nickname from the character in *Amos 'n' Andy*.

☐ Jack Lord, star of *Hawaii 5-O*, has three woodcuts and two lithographs hanging in the Metropolitan Museum of Art under his real name, J. J. Ryan.

☐ A 1979 Roper Poll of 3001 couples showed that the leading cause of marital disputes was disagreement about which TV shows to watch.

☐ An average child watches 28 hours of Television a week and sees 20,000 TV commercials every year. An average pre-schooler watches 33 hours per week. The typical 5-year-old has spent more time in front of the TV set than a college student spends in four years of classes.

☐ By age 15, a typical kid will see 13,400 killings—most of them on Television.

☐ If you were guilty of every crime shown on American TV in just one week, you'd go to jail for 1600 years. Unless you had Perry Mason for your attorney.

TV Psychotherapy:

The "Freud Potato" Approach to Mental Health

By Dr. Davenport H. Spudd

NOTE: Dr. Spudd is the only living authority on TV Psychotherapy, a branch of psychology so new that not a single paperback self-help book has been written about it until now. In Dr. Spudd's search for new sources of wisdom about the human psyche, he has obtained videotapes of every network TV appearance of Dr. Joyce Brothers and studies them often.

I have found in my research that the simple act of watching Television is therapeutic, no matter what you watch. Did you ever notice how refreshed and relaxed you feel after an evening in front of the tube? Studies show that Prolonged Television Viewing relaxes the body, lowers breathing and heart rates, stimulates alpha waves in the brain and relieves pain, anxiety, and feelings of alienation—in short, everything TM promised but never delivered. In fact, nearly 90% of all psychological problems will disappear if you watch enough TV. Imagine: complete mental health without painful introspection, without doctors, and with drugs optional.

Corrective Viewing

Some Couch Potatoes do have psychological problems, from mild "videosyncrasies" to extreme Telecastration Anxiety and Zenith Envy. Only one in ten conditions is serious enough to require Corrective Viewing treatments, a regimen of prescribed TV shows designed to tune out your mental static, but many Couch Potatoes use these techniques just for the peace of mind they bring.

Video Psychosymbolism. TV shows are often rich in deep, symbolic meaning, and can effect amazing cures on even the most disturbed patients.

Take for example *Gilligan's Island*. Each of the characters symbolizes one of the basic elements necessary for a healthy, balanced psyche. Gilligan represents impulsive, childlike spontaneity; Skipper is the judgmental superego; the Professor is, of course, the rational intellect; Mary Ann

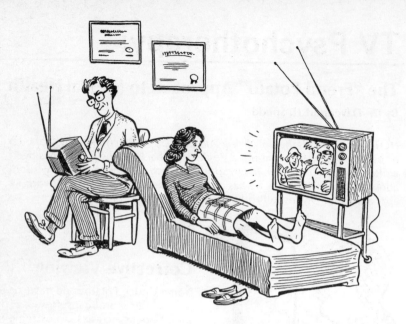

symbolizes emotion and concern for others; the Howells are the narcissistic ego; and Ginger is sexuality personified.

The show is a metaphor for mental illness. The psyche is "shipwrecked" and isolated by the imbalance of its elements. (Remember how the Professor and Mary Ann used to be just ". . . and the rest"?) During their long isolation the various elements become unified, balance themselves, and the cured mind returns again to the world of sanity.

It sounds unlikely, I know, but believe it or not, I have seen severely troubled patients become healthy, if somewhat "zany," adults simply by watching all 113 episodes of this remarkable program in succession over a weekend-long marathon.

Cathode Catharsis and Role Modeling. Take the first step toward stabilization of your mental horizontal hold by unblocking your repressed emotions through Television. One patient of mine, a male, had trouble expressing sadness. I prescribed several boxes of Kleenex and forty hours of *Queen for a Day.* After only a few hours of this, he was sobbing like a baby.

In another textbook case, a woman came to me with repressed anger. She was afraid of expressing it, afraid she'd turn into a destructive, murderous "monster." After just twenty hours of seeing her fears acted out via *The Incredible Hulk,* she was able to laugh at them. She is now free of her anxiety, contentedly spending 10-to-life in

San Quentin for assault with a deadly weapon and cannibalism.

Once, a man in his late sixties came to me for guidance. He was concerned about growing old. In our first session, I prescribed *Over Easy* and a press conference with Ronald Reagan, to little effect. The next time, I tried selected episodes of *The Real McCoys* that emphasized the positive role of Grandpa Amos. In just a few hours, his spirits took a turn for the better, and now, when he's not watching TV, he can be seen limping around his neighborhood shouting happily, "Little Luke! Pepino!"

Other programs offer similar comfort in disturbing everyday situations. Feeling powerless? Charge up with megadoses of *Mighty Mouse, Superman* and *Mr. Terrific.* Anxiety about death? Try a few reruns of *Topper* or *My Mother the Car.* Family problems? Watch *The Waltons* or *Father Knows Best.* If you're feeling depressed about being a single parent, a dose of *Bachelor Father, My Three Sons* or *One Day at a Time* will set you right again. Whatever your problems, there are TV shows out there just waiting to help.

Remember, personal happiness is as close as your color RCA. Try TV psychotherapy on your own and see how much it helps. However, if your problems persist, take two *Bob Newhart Shows* and call me in the morning.

Simulviewing

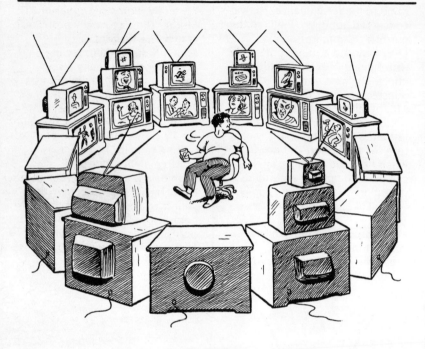

What is it?

Simulviewing is the practice of watching more than one Television at a time. It is rapidly increasing in popularity as a viewing technique. With the video explosion of the last few years, there are dozens of programs on at any one time that you can't afford to miss. A videocassette recorder is one solution, of course, but many Tubers enjoy the pleasure of stacking up their TV sets and watching them all at once. Some Couch Potatoes habitually watch ten or more sets simultaneously.

Why do it?

Well, obviously, so you don't miss anything good. Beyond that, Simulviewing can put you in touch with the world around you. You can vicariously live hundreds of lives in thousands of locations, past, present and future. The act of Simulviewing encourages you to break out of conventional, vertical thinking patterns and think horizontally. And by learning to absorb the action on several screens at once, you'll learn to cope with living in today's fast-paced world.

How to Do It Right and Without Injury

Simulviewing can be dangerous if practiced carelessly. Many novices suffer injuries from jerking too quickly from one screen to another (see page 50). They haven't mastered the technique of true simultaneous viewing.

The following suggestions will help you get started safely.

☐ Don't overdo it. Start small, with just one extra set. Gradually build up as your comprehension increases.

☐ Keep all sets as close together as possible in order to reduce eyestrain and the possibility of neck injury. "TV in the round" viewing is only for extremely advanced Simulviewers.

☐ Protect yourself from eyestrain by keeping your eyes slightly out of focus. This will improve your peripheral vision and help you avoid staring at one screen too intently.

☐ Begin with the sound turned down to decrease distraction. When you are visually coordinated, turn up the sound of one set, then the others, one at a time. Keep the volume on all TVs at the same level. You will eventually learn to follow all the soundtracks at once.

☐ While learning to simulview, stay away from snacks that can't be eaten without silverware, or that require you to look at them when eating. Twinkies and Ding Dongs are ideal, but remember to unwrap them all before you begin.

Increasing Your Pleasure

Once you've learned the basics, you'll be able to advance rapidly. Add as many Televisions as you can afford. (One of the advantages of joining a Couch Potato Lodge is being able to simulview for only the cost of the set you donate; the bigger your lodge, the better your sessions.)

You can also vary your Simulviewing sessions by adding "extranormal" TVs to your lineup. I find it amazing that people throw out perfectly good Televisions just because the picture isn't quite right. I've adopted several of these old gems and they've enhanced my viewing pleasure by adding a fine art dimension. One makes the bottom half of the screen stretch out so that everybody looks like Kareem Abdul Jabbar. Another, with a vertical hold problem, gives me the bottom half of the picture on top and the top half on the bottom—a real challenge. My favorite gives a clear, sharp picture in sepia tones so that everything on it looks like a 19th century daguerrotype. These nonconformist TVs are cheap, if not free, and they make excellent additions to any Simulviewing environment.

☐

Unsung Heroes of the Couch Potatoes

CHARLES SOPKIN
inventor of Prolonged Simulviewing

From April 22-29, 1967, Sopkin sat from 7 AM to Midnight in front of six Television sets tuned to the six New York City commercial stations available at the time. He wrote about the experience in *Seven Glorious Days, Seven Fun-filled Nights,* still required reading in many Couch Potato Lodges.

In the book's introduction, Sopkin explained that he was inspired to embark on his pioneering endeavor by Fred W. Friendly, a former CBS News president, who'd suggested that each network head be forced to watch the programming on his network for an entire day. Sopkin decided that if a day was good, a week would be even better, and took it upon himself to be the first to try it.

For some reason, his initial reaction was negative. "I will freely confess," he wrote, "that, immediately after my week-long ordeal, I thought that the only way to solve Television's problems was, literally, murder—i.e., send in squads of machine-gunners and summarily execute every executive at every network and start from scratch. I have cooled down a bit since then. My frank opinion is that there is *no* way to make Television better. It is what it is."

Couch Potatoes everywhere rejoice that Sopkin finally saw the light: there *is* no way that Television could be made better than it is.

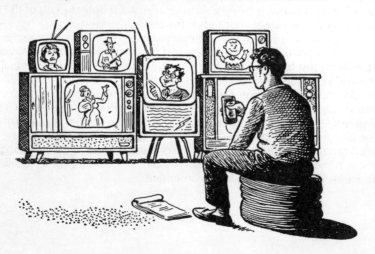

In Search of . . .
TV Before TV

History tells us that mankind was without Television until A.D. 1927, when it was "invented" by Philo T. Farnsworth of San Francisco, California. But did Farnsworth *invent* the Television — or did he *rediscover* it?

Fascinating new discoveries by Professor Dick Von Dannikaye, author of *Trinitrons of the Gods?* indicate the possibility that so-called primitive man may have lived very much like the stone age families on the *Flintstones*, and that the Television played a central role in many ancient cultures around the world. Consider the following.

■ Clay tablets unearthed in Mesopotamia — the "cradle of civilization" — once thought to bear religious inscriptions have been shown to be primitive TV guides that indicate the existence of at least *four* major networks.

■ A number of cave paintings discovered in southern Spain depict what appear to be crude stick figures gathered around a rectangular box that bears an uncanny resemblance to a 1965 Model Airline Brand Television from Wards.

■ At Stonehenge in England, the massive stone structures from a lost race have long been known to be sophisticated astrological instruments that were used to predict celestial phenomena such as eclipses and the change of seasons. Yet until recently, scientists were unable to determine the purpose of one grouping: a slab 2 feet, 11 inches high, surrounded by a semicircle of flat, rectangular slabs, 1 foot, 10.5 inches high. Between these slabs are small stone pedestals 2 feet, 8 inches high. Remarkably, this array conforms exactly to the measurements suggested by the American Television Bureau's Standardization Committee (ATBSC) as the optimal position and height for the modern Television stand, viewing couches and TV trays!

A coincidence — or more astonishing evidence that primitive man knew about Television eons before us?

■ The Bible, in the book of Exodus, relates Moses's encounter with a mysterious burning bush: "Behold, the bush burned with fire, and the bush was not consumed." Could

this not be a primitive description of man's encounter with TV?

The "bush" spoke to Moses. It said, "Put off thy shoes from off thy feet, for the place whereon thou standest is holy ground." A warning—or an invitation to "kick your shoes off and set a spell"?

■ Plato's *Republic* is one of the great legacies of the western world. We are all familiar with his analogy of the cave, where men, bound to face one way, perceive the world as flickering shadows on the wall animated by a "fire" they cannot see. Any Couch Potato will easily recognize the similarity of this description to a modern-day viewing module equipped with wall-sized projection TV.

If ancient man had Television, where did it come from? Was TV a gift of alien "gods" in flying saucers? Was God a VCR? How does one explain the immense, placid faces erected by a forgotten culture on Easter Island, or the curious TV reception in the area known as the Bermuda Triangle? And most important, why did Television disappear, only to be "invented" again in the 20th century?

All we know is that some time around the 14th century, evidence of TV use disappears. Some postulate that the invention of moveable type caused drastic changes in world history by spreading literacy to the

corners of the known world, virtually wiping TV off the face of the Earth. For half a millenium, only the most enlightened minds recalled and paid tribute to Television. The visionary poet William Blake, for example, penned the following lines:

> This Cabinet is form'd of Gold
> And Pearl and Crystal shining bright
> And within it opens into a World
> And a little lovely Moony Night

Blake's passion for Television was immense. He longed to commune with it, probe its inner secrets, but alas!

> I strove to seize the inmost Form
> With ardor fierce and hands of flame
> But burst the Crystal Cabinet
> And like a Weeping Babe became

Who amongst us cannot empathize with Blake's despair when he accidentally put out his picture tube and there was not a TV repairman to be found anywhere?

But perhaps the most startling proof of early Couch Potatoes amongst us is to be discovered in the archives of our country's founding fathers. An early draft of the Declaration of Independence, discovered in the papers of Benjamin Franklin, proves that the famous self-evident truths of "Life, Liberty and the Pursuit of Happiness," were very nearly "Baseball, Hot Dogs, Apple Pie and Chevrolet."

Von Dannikaye's critics abound. They claim his research is shallow and his evidence unconvincing. They refuse to admit that Television might have been of strange and ancient provenance, but Von Dannikaye is undeterred. He continues to search wherever new findings indicate the existence of. . . the Trinitrons of the Gods.

The History of the COUCH POTATOES

The Couch Potatoes, like almost everything good about Television, had their origins in sunny southern California. There the founding members invested their childhood years in countless hours before their TVs . . .

In the early 1960s, these devoted viewers arranged to get together Thursday nights to follow the adventures of the Space Family Robinson and Dr. Zachary Smith on *Lost in Space* They called themselves the *Lost in Space* Club.

They began meeting more often, on other nights and Saturday mornings, for all kinds of TV events.

One of them, known only as "The Hallidonian," soon made the discovery that any day, any time was all right for prolonged, indiscriminate TV viewing

He could remain poised on the couch for days on end, sometimes weeks, to everyone's amazement He was the group's inspiration—the first true Televisionary.

It was in reference to "The Hallidonian" that Elder Tom Iacino coined the term "Couch Potato." It was shortly adopted as the name of their organization

These nine friends became the first Couch Potato Elders, and "The Hallidonian" was unanimously proclaimed "Numero Uno."

The Couch Tomatoes were founded soon after as a women's fetch and adjust auxiliary. They were content with their inferior positions in the Viewing Lodge for a time, until one evening, one of these Couch Tomatoes came to an important realization while watching the *Mary Tyler Moore Show*:

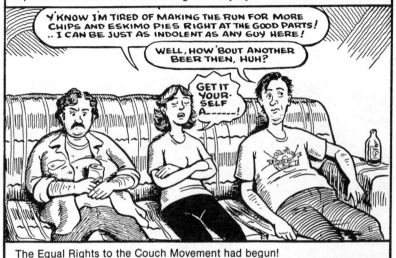

The Equal Rights to the Couch Movement had begun!

Members were proud to be called Couch Potatoes or Couch Tomatoes, but to the rest of the world, they were bums

They were easily distinguished by their healthy pallor and robust bulk in the land of lean, sunbaked, bleached blond beach boys and girls.

They were ridiculed by their friends and families. They became outcasts. They were forced "underground," where they took solace in their Viewing Lodge and unlocked the secrets of TV through Prolonged Viewing.

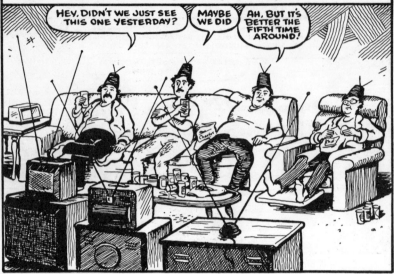

The only outlet these Tubers had for their ideas at first was the Underground Comics. In them they began placing obscure references to their organization . . . not yet daring to hint at the secrets they'd discovered.

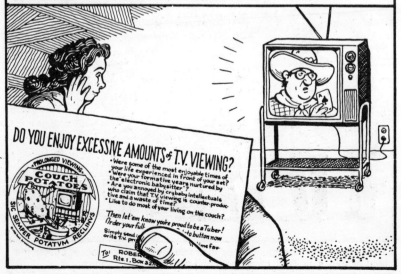

Then, in 1979, the Couch Potatoes surfaced in Pasadena's famous Doo Dah Parade They dropped out the next year because motorized floats were outlawed, and no one wanted to pull the Ceremonial Couch.

But slowly, the membership grew. The movement struck a chord in society, and in today's troubled economic and intellectual climate, it is rapidly gaining importance as an alternative lifestyle.

Today, there are official Couch Potato Lodges around the world—some are reported to thrive behind the Iron Curtain. The Couch Potatoes even manage to publish a newsletter, *The Tuber's Voice*, that's become a forum for the testimonials and opinions of Couch Potatoes worldwide.

Is There Room on the Couch for Me?
OFFICIAL COUCH POTATO ANTHEM

by Elder R. E. Armstrong

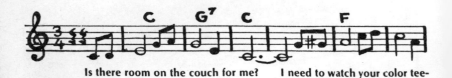

Is there room on the couch for me? I need to watch your color tee-

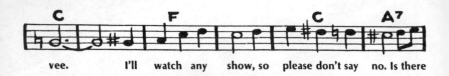

vee. I'll watch any show, so please don't say no. Is there

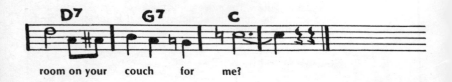

room on your couch for me?

2.) So pass me the new *TV Guide*.
I need it here right by my side,
So I can peruse
The listings and choose
A program. It'll help me decide.

3.) Here's a rerun I've only seen twice
And the color is lifelike and nice.
The picture looks keen
On a 26-inch screen.
Your TV was well worth the price.

4.) Let's have plenty of snacks on the tray
To nourish us on through the day.
'Cause I sure hate to move
When I'm settled in the groove.
And the kitchen is so far away.

5.) There's a guy here I'm ready to stab,
'Cause all he can do is blab
Through my favorite show.
I think he should know
That we're all here to watch and not gab.

6.) I'm ready to weather Life's storm,
As I sit in this leisurely form.
But if ever I die
Please try not to cry.
Just make sure my spot is kept warm.

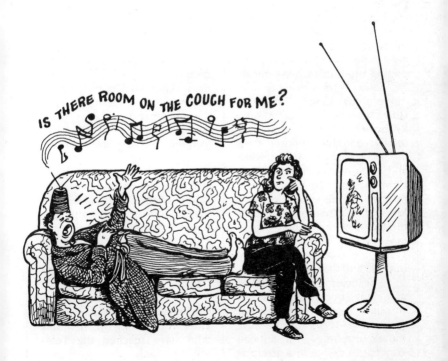

IS THERE ROOM ON THE COUCH FOR ME?

The Couch Potato Elders

What purpose do the nine Couch Potato Elders serve? Many younger members wonder, as the Elders don't seem to *do* anything but lounge around and stuff food in their faces. In fact, the Elders have many duties, the most important of which is interpreting the hidden messages in TV shows. Television is our modern-day oracle, and the Elders have been entrusted with its power. Each of them has totally committed himself to a life of Prolonged TV Viewing and, in the wisdom of the Blue Light, has earned his honored position in the sacred viewing lodge. The pronouncements of the Elders, when made *ex cathode ray* from the Laz-E-Boy of Truth, are considered divinely inspired and therefore infallible.

Vacancies in the Elderhood can only occur three ways: through death, blindness or gross moral turpitude. Because moral turpitude is a difficult concept to define in a group as amoral as the Elders, only a few have been deposed on these grounds. Blindness is more common. Many Elders have been afflicted during the mystical "Colored Snowflakes Ceremony," in which the TV is viewed from a distance of a few millimeters, continuously, for several days. While the Couch Potatoes welcome blind members, it is thought that the Elders must have the power of sight in order to fulfill their responsibilities.

The death of an Elder causes special problems for the organization. Many Elders have gone unreplaced for weeks after dying by virtue of the fact that it is often very difficult to tell the difference between a dead Elder and a live one in his TV-induced trance.

When a vacancy does occur, the remaining Elders elect a new Elder from among the members who have reached the Televisionary rank.

Spreading the Word Abroad

"Television is now recognized everywhere as a vehicle for education and information, a force to arouse and unify developing nations, and a symbol of national status and prestige that soars above the home-grown airline."

—ROBERT E. KINTNER

Imagine, if you can, living in the steaming jungles of darkest Africa. Your only friends are your tribe-mates and the wild animals; your only entertainment, warring with neighboring tribes. You live without the benefits of civilization: no electricity, no toaster ovens, no TV trays—no TV.

No TV! A nightmare most of us have trouble imagining. Yet that is precisely the nightmare that awoke Couch Potato missionary Wordham R. Sponsor from a sound sleep in August, 1978. That very night he made a solemn vow: "I shall make the Third World safe for Television, in the name of *Tarzan, Daktari,* and *Kimba the White Lion.*"

A formidable challenge? You bet. Yet if anyone could do it, Sponsor could.

Sponsor, who'd emigrated from his native England in 1948 escape what he called "the tyranny of BBC programming," was the founder of the famous Videon Society, the organization dedicated to placing TV sets in hotel and motel rooms across the nation. When Sponsor began the Videons in 1950, there were 50 motel rooms without Television to every one with. Today, that ratio is closer to 500 rooms with TV to every one without. What better evidence is there of Sponsor's faith and perserverance in this noble cause?

With his solid credentials, the Couch Potato leadership voted unanimously to sponsor Sponsor, and his new outreach program, Sets for Savages, Inc., was underway. In the Spring of 1979 he began his mission by placing a Television set, a toaster oven, a set of matching TV trays, a small generator, a VCR with a library of video classics (since Sponsor considers Third World broadcasting just as suspect as the BBC), a packet of Couch Potato literature in the tribal language, several cases of Viewmeister and a three-year supply of Doritos in each of several deprived tribal villages of Africa, India and South America.

Since that time, Sponsor has brought the Blue Light to thousands more worldwide, but his work cannot continue without your help. You can support this noble effort by sending tax deductible contributions to Sets for Savages c/o the Couch Potato Headquarters. And watch your local listings for upcoming celebrity telethons. With your help, we can help illuminate the darkness of ignorance with the brilliance of the TV screen.

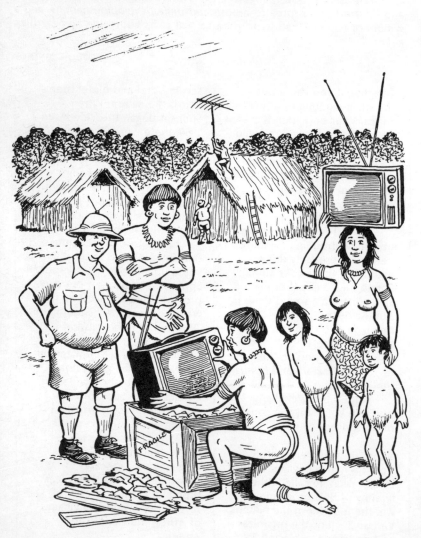

Television
Around the World

In the little English-speaking country of Belize (pop. 140,000 people, 12,000 TV sets), the only TV transmissions are signals pirated from U.S. network satellites. "All my students have become Chicago Cubs fans," said an American priest-schoolteacher. "I have to take time out from class to explain the fine points of the game."

The Japanese watch more TV than anyone (U.S. viewers are a close second). In Japan, the national TV craze is called *ichioko-so-hakuchi-ka* 億総白痴化 or "the complete idiotization of 100 million people."

In the U.S., there are 571 Televisions for every 1000 Americans. Upper Volta has but one TV for every 1000 people.

Iceland, not generally considered a repressive country, has a TV-free day every Thursday "to reduce disruption to family life."

In West Germany, zookeepers put a TV near the gorilla cages in hopes of increasing their sexual activity. As any Couch Potato could have predicted, the tactic didn't work: the gorillas decided they'd rather watch TV. Their preferences: love scenes, followed by weight-lifting and auto racing.

Sesame Street is so popular in Pago Pago that the government once considered naming the island's main street after it.

Bonanza is the most widely syndicated TV series. It has 250 million viewers in 85 countries.

Columbo is the most popular American program in Eastern European countries. The communist leadership approves because Columbo is a working class detective who mostly goes after rich capitalist criminals.

When the tide goes out in Carradale, Scotland, so does the TV reception, for reasons unknown. Authorities speculate that the exposed mud absorbs TV signals.

In Yugoslavia, all the commercials are shown non-stop during one half-hour program each evening. The show is called *Ekonomska Propaganda* ("Economic Propaganda") and many people actually watch it.

Charlotte Gardener, 86, of London, was killed by her Television set. She kept it on 24 hours a day for two years and a component burned out. The fumes killed her.

A UNESCO Study found that TV-owners worldwide sleep an average of 13 minutes less per night than non-owners.

TV was banned in South Africa until 1975. The government was afraid it might threaten the precarious apartheid system there. Even now, TV sets cost double what they would elsewhere to keep them out of the homes of Black citizens.

Enemies of the Movement

"The Neilsen ratings are democracy in action—they preserve the public's voice in Television programming by reporting what people prefer to watch."
—ARTHUR J. NEILSEN

There are more people opposed to Prolonged Television Viewing than you can shake a remote control tuner at. No matter where you turn there's somebody waiting to bad-mouth Television. Lately, these fanatics have begun to organize, and their virulent anti-TV protests pose a threat to Couch Potatoes everywhere.

The Censor Groups

The Couch Potatoes are opposed to any outside interference in the decisions of network executives and advertisers. Pressure groups that denounce sex, violence, unpopular political opinions and advertisements for dubious or unhealthy products on TV threaten the integrity and quality of the TV programming we have grown accustomed to.

These so-called "moralists" come from all parts of the political spectrum, but all share the common misconception that TV viewers will emulate whatever is portrayed on Television to the detriment of society. Quite simply, these people are well-meaning but misguided. They are attacking the problem in exactly the wrong way. *When people are watching Television, they don't have time for antisocial activity.* Or sex, either (ask any married couple).

If these censor groups really want to keep sex and violence out of our homes and off of our streets, they should join the Couch Potatoes in their fight to keep them where they belong—on our TV screens.

The Neilsen "Family"

The membership of this subversive group is a well-kept secret, but it's rumored that even apparently upstanding citizens are a part of it. The "Family" attacks Couch Potatoes indirectly by "rubbing out" (i.e., cancelling) their favorite TV shows. Few programs die naturally anymore—most are given the "kiss of death" by the Neilsens before their time. Recent favorites, such as *Barney*

Miller, WKRP In Cincinnati and *Charlie's Angels* were all "cancelled" by the brutal axmanship of these cold-blooded killers.

The Manderites

No other group strikes as much terror in the hearts of Couch Potatoes as the Manderites. These extremists have claimed responsibility for much of the anti-TV violence in recent years, including bombings of Television stations in Detroit, Newark and Houston.

The Manderites take their name from their unwitting guru, Jerry Mander, author of an inflammatory 1978 book called *Four Arguments for the Elimination of Television.* (Elimination!) While Mander doesn't specifically advocate *violence* against TV, he does argue that it should be abolished. (According to reliable sources, Mander developed his irrational hatred for TV when, as a child, people to whom he was introduced would invariably remark, "Jerry Mander? That's funny. You don't *look* like the Beaver.") And though Mander repudiates the Manderites and their methods, they have adopted him as the hero of their cause and commit unspeakable acts against TV in his name.

According to the President's Commission on Violence Against Television, videocide and other serious crimes against Televisions have increased 4300% since the first reported TV murder by gunshot in 1953. Each year, "Man Shoots TV" stories increase, and though the media portrays these people as crazed, lone assassins, most are card-carrying Manderites.

Couch Potato Elders have been forced to take elaborate precautions to protect themselves since a Simulviewing seminar in Louisville was forcibly broken up by Manderites in 1981. And still more heinous acts have been reported: the smoldering, mutilated bodies of kidnapped Televisions—thought to have been stolen by underprivileged citizens trying to upgrade their video systems—have been found along deserted roads, their tubes disemboweled, knobs amputated, rabbit ears horribly bent and imitation woodgrain finish scarred beyond recognition.

This sort of senseless violence must stop, but until these animals are caught, Couch Potatoes must remain vigilant, ever on guard to protect the sanctity of their viewing modules and the safety of their sets.

Deprogrammers

Deprogrammers are fanatics who claim that the Couch Potato organization is a cult that deprives its members of God, free will and the Protestant work ethic. They line their own coffers with the money of gullible families who have been convinced that their "prodigal viewers" need "deprogramming."

This could happen to you: You are sitting comfortably in front of your Electronic Hearth watching *Laverne and Shirley.* Suddenly, without warning, a half-dozen goons kick down your door. Deaf to your pleas to wait for the station break, they pull a blanket over your head, tie you up and throw you into the back of a van. They then subject you to the worst torture imaginable: days, even weeks without

television, and all the time haranguing you with verbal anti-TV abuse.

When convinced they've broken your spirit, "Rechanneling" begins. They'll try to be buddy-buddy with you and attempt to get you to try reading, jogging and other addictions to replace your allegiance to TV. Their tactics are ruthless, and many Couch Potatoes have cracked under the strain, but fortunately, most have gone back to viewing shortly after their ordeal.

How to Survive "Deprogramming"

If your family is hostile to Television, don't visit them. Many kidnappings occur in parents' homes. If your family visits you, keep your TV on at all times, and make sure you have several fellow Tubers around you.

If Deprogrammers grab you, give only your name and your five favorite TV shows.

Don't listen to Deprogrammers. Quietly sing TV theme songs to yourself. Close your eyes and mentally rewatch your favorite episodes of *The Prisoner*. Pretend that their harangue is nothing but a bad stream of commercials. If they physically abuse you, pretend you're a contestant on *Truth or Consequences*.

Pretend to go along with them, agree to whatever they say, and look for a chance to escape.

When your ordeal is over, press kidnapping charges against your family. Even if your gray-haired mother ends up doing time for her crime cheer yourself with the knowledge that you are making the world safe for Couch Potatoism.

TV
FACTS
#4

Mighty Mouse was the first Saturday morning cartoon series on network Television. It began on December 10, 1955.

The first TV soap opera, *Faraway Hill*, debuted on October 2, 1946. It was cancelled before Christmas the same year.

One of the most unlikely network creations ever was the ABC vehicle, *The Mail Story*, based on the files of the United States Postal Service. The series, which began in the fall of 1954 and was cancelled three months later, starred Herb Nelson as a "relentless" mail inspector.

Cats are more likely to be TV viewers than dogs.

Roy Roger's "Trigger" was actually four different horses. "Lassie" was a series of male dogs.

Dealing with the Networks

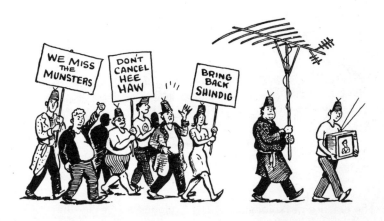

There is nothing more frustrating than having your favorite TV show cancelled by some faceless network assassin for some crass mercenary reason or another. Many Couch Potatoes have actually thought about maybe complaining or something, but protesting is not only boring, it consumes video time and probably isn't effective.

If you are driven to take some sort of impulsive action, make sure you are using the most effective means of communication. Don't grovel and plead. You'll get a patronizing form letter for your trouble. Don't even be civil.

Instead, be abusive. Make personal threats. Let those network wimps know they're dealing with somebody who can't be pushed around, somebody who's mad as hell and isn't going to take it any more. Make them back down. While these tactics are not for the squeamish, nor for those with any scruples, it's a lot more effective than circulating petitions or boycotting sponsors' products.

But before you make any sort of protest about your favorite show being cancelled, consider this: the people at the network may have better taste than you.

The Tao of Television:

Inner Peace Through Transcendental Vegetation

"I view because I view."
—ANONYMOUS

The practice of Prolonged Viewing is the western equivalent of Taoism, the ancient art of growing wise while not doing much. Many Tubers follow the Path of Least Resistance and view indiscriminately, without regard for programming. They quote the adage, "It's not *what* you watch, but *how* you watch it." Dedicated pacifists, they will sit for hours watching the most brutal acts TV can throw at them — police shows, war movies, football games, even Saturday morning cartoons. Less patient Couch Potatoes will consult the "Book of Changes"—the *TV Guide*.

Some members have de-veloped a Zen Viewing discipline. They rid themselves of all worldly possessions but their TV sets and viewing tunics, and retire from society. Some gather around one particularly sage viewer who instructs his "disciples" in the mysteries of Television. This "master" will often pose paradoxical Zen *Koans* with distinct video overtones. He will ask, "What do you want, good grammar or good taste?" or "Wouldn't you really rather have a Buick?" or "Does she or doesn't she?" Young Zen viewers grapple with these problems until they achieve Enlightenment.

TV Guidance:

How to Tell the Future With Your TV Set

By Quasar Dumont
Televisionary and TV Mystic

The medium is the message, and your TV is the most powerful psychic medium of all. Every image on the screen, from made-for-TV movies to cartoons and commercials, is full of occult meaning, just as there is meaning in Tarot cards or the *I Ching* . . . or in Chinese fortune cookies, for that matter. TV is a reflection of the universe. What you see on Television might be yourself several years from now, or the person you'll marry, or the answer to the question you have been asking for years, or the exotic Caribbean port you knew must exist but could never find.

Spiritually advanced Couch Potatoes of the Televisionary rank are able to "tune in" to these cosmic messages at will. They have learned the esoteric art of interpreting the images properly. Novice viewers, on the other hand, get caught up in superficial messages of plot and product, or else leap to preposterous conclusions based on what they *think* they have experienced in front of the TV. Their foolishness gives all of us a bad name.

This is no parlor game! It is a discipline that requires intense concentration on what is being said and portrayed, and hours, sometimes weeks, of Prolonged Viewing. You can't expect miracles in just one episode of *Twilight Zone*, but the following exercise *will* enable you to focus more intently on the oracular properties of your TV.

TV Guidance

Step One:
Clear your mind. Relax and become receptive to the cosmic influences. Sit in quiet meditation with your TV tuned to the last channel you were watching, but with the sound turned all the way down. What you see there is your first Guidance Point.

Step Two:
If your *TV Guide* is a new one, open it and flex the binding a few times. Then, holding the *TV Guide* between your hands, ask your question. For best results, keep it short and to the point. For example: "Should I do such and such at this time or not?"

Step Three:
Turn the sound up. Pay very close attention to what happens on the screen and soundtrack following your question. After 20 seconds or so, turn the sound down again and repeat mentally what you have seen and heard.

Step Four:
Reverently toss the *TV Guide* into the air and let it fall on the floor. If it lands with the front cover up, switch the channel forward to the next station (skip by weak stations or channels with no picture). If it lands with the back cover up, go backwards one station. If it lands open, go forward three stations. Switch from VHF to UHF when you hit the "U" on the knob (if you have UHF). Switch back to VHF if you hit either end of the UHF spectrum. The station you land on is your next Guidance Point. Follow the instructions in Step Three.

Step Five:
Repeat Steps Three and Four until you have seen a total of five 20-second sections. Try to remember all of them in order. Now comes the challenging part.

Step Six:
Interpret the images as they apply to your question. Did any of the segments directly answer your question, or were they all cryptic? Was there a relation between the segments? What was the general *tone* of those segments? Happy? Foreboding? Comical?

The overall tone is important because a single image, taken out of context, can be misinterpreted. I once had a TV Guidance session with a man concerning a risky project he was considering. In one of the segments, a cartoon character attempted to tackle an enchanted suit of armor. He took a running leap and sailed right through it. My client's head dropped, thinking that this was an omen of futility and certain failure. I reassured him, though, by pointing out the incredible optimism of a Dr. Pepper commercial we had

also seen. The TV oracle was telling him to take a good running leap at his project, and that he'd sail right through it. Weeks later, he called to let me know that my interpretation was correct and that the project was a success.

In 1980, I attempted to divine the winner of the upcoming presidential election for a major tabloid. This, I might add, was at a time before all the candidates had even announced themselves. I used the TV Guidance technique and received the following images:

1. A scene from a comedy series in which the husband is trying to teach his scatterbrained wife to drive. He tells her to turn left, but she turns right, swerves onto the sidewalk, runs over a fire hydrant and crashes into a grocery store. This told me that the electorate would take a conservative turn with bad results for the economy ("crash" of the "market").

2. A scene from *The Grapes of Wrath* — further confirmation of bad economic news.

3. A Sci-Fi movie in which the heroes battled it out with ray-guns.

4. A McDonald's commercial featuring their clown, Ronald.

5. A scene from *Gomer Pyle*: "Well, golly, Sergeant Carter. I'm awfully sorry." Bad news, for the incumbent, obviously.

By putting all these interpretations together, I easily predicted the election results well in advance of the New Hampshire primary. Amazing, isn't it? But simple, once you realize what a powerful influence Television has had on our lives.

"I believe Television is going to be the test of the modern world, and that in this new opportunity to see beyond the range of our vision we shall discover either a new and unbearable disturbance of the general peace or a saving radiance in the sky. We shall stand or fall by Television—of that I am quite sure."

—E.B. WHITE, 1938

Appendix

How to Join the Couch Potatoes

"(Television) is a medium which permits millions of people to listen to the same joke at the same time, and yet remain lonesome."

—T.S. ELIOT

There's no reason for any television viewer to feel lonesome ever again. Think about it, and you'll find it reassuring to know that no matter when you view there are Couch Potatoes out there viewing with you.

If you believe you have what it takes to be a Couch Potato or a Couch Tomato, pick up a pen or pencil during the next commercial break and write to the Couch Potato Headquarters, P.O. Box 249, Dixon, CA 95620.

Send to us:
- A short statement of your qualifications.
- A list of your five favorite shows of all time.
- $5 for processing, membership card and four issues of *The Tuber's Voice*.

We will, of course, accept applications made in proxy for Tubers who are too busy watching Television to apply for themselves.

How to Join an Official Couch Potato Lodge or Start Your Own

The Couch Potatoes recognize the pleasures of solitary or tandem TV viewing, and members are not required to join a Lodge. However, Lodge membership is recommended for several reasons:

- To meet other people who share your devotion to Television.
- To help strengthen your commitment to the Couch Potato Lifestyle in times of crisis and self-doubt.
- To effect savings in equipment and food costs by pooling Televisions for Simulviewing, sharing the toaster oven, joint subscriptions to *TV Guide*, etc.

The "Siblinghood of the Sofa" is a powerful force and the very cornerstone of the Couch Potato Movement. If Lodge membership is right for you, write Couch Potato Headquarters for the name of the Lodge in your area.

If your local Lodge has no openings, or if it doesn't suit your needs, you can start your own. All you need are two or more fellow Couch Potatoes (or Couch Tomatoes), and a stamp to send the following information to Couch Potato Headquarters, P.O. Box 249, Dixon, CA 95620.

1. Location of Lodge
2. Mailing address
3. Lodge nickname (if any)
4. List of founding members
5. Number of TV sets in Lodge
6. Lodge slogan (if any)
7. Five dollar one-time registration fee to cover the cost of an Official Couch Potato Lodge Certificate and membership cards.

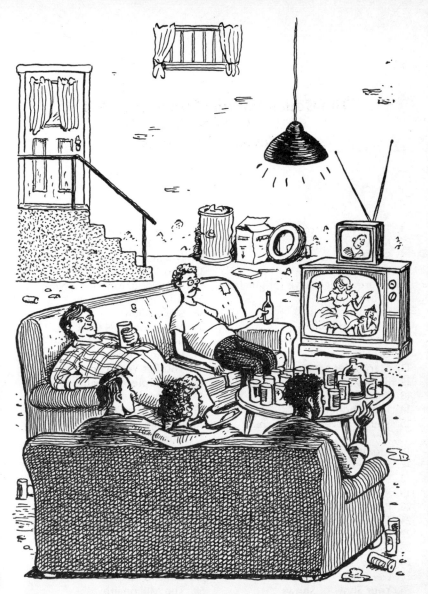

Lodge #114, Detroit, Michigan. Nickname: "The United Ottoman Workers."
Determined not to let the Detroit economy get them down, these party-loving
midwesterners watch Television in around-the-clock shifts, and have vowed to
continue to do so until unemployment gets down below 4%. The Lodge hosts open
houses, drinking games and viewing competitions. Favorite shows: local polka
shows, *Soul Train*, sports.

The Couch Potato Membership Poll
of the All-Time Top 100
Television Programs

1. The Twilight Zone
2. M*A*S*H
3. Star Trek
4. Leave It to Beaver
5. Saturday Night Live (original)
6. I Love Lucy
7. Honeymooners
8. Beverly Hillbillies
9. Bob Newhart Show
10. Green Acres
11. Mary Tyler Moore
12. Barney Miller
13. The Rockford Files
14. The Prisoner
15. You'll Never Get Rich (Sgt. Bilko)
16. Monty Python
17. Dobie Gillis
18. SCTV
19. Rocky & Bullwinkle
20. Perry Mason
21. The Avengers
22. Hill Street Blues
23. Dick Van Dyke Show
24. Ozzie & Harriet
25. Get Smart
26. Your Show of Shows
27. All In the Family
28. Andy Griffith
29. Alfred Hitchcock
30. Ernie Kovacs
31. Outer Limits
32. Amos 'n' Andy
33. Topper
34. Dragnet
35. Taxi
36. Fernwood/America 2-Nite
37. Addams Family
38. Steve Allen
39. Man From U.N.C.L.E.
40. Bonanza
41. Hogan's Heroes
42. You Bet Your Life
43. Masterpiece Theatre
44. Maverick
45. Father Knows Best
46. Gilligan's Island
47. Combat
48. Kung-Fu
49. 60 Minutes
50. Mary Hartman, Mary Hartman
51. Fawlty Towers
52. Bugs Bunny
53. Have Gun, Will Travel
54. Tonight Show
55. Lost In Space
56. "Football"
57. Burns & Allen
58. The Millionaire
59. David Letterman
60. Life of Riley
61. The Love Boat
62. Mr. Ed
63. Gunsmoke

64. Rawhide
65. Soap
66. Wild, Wild West
67. Car 54, Where Are You?
68. Jack Benny
69. Police Squad
70. 77 Sunset Strip
71. Three Stooges
72. Benny Hill
73. Untouchables
74. Sky King
75. WKRP In Cincinnati
76. Gomer Pyle
77. People's Court
78. Superman
79. Queen for a Day
80. My Little Margie
81. Dallas
82. My Mother the Car

83. I Married Joan
84. Soupy Sales
85. Brady Bunch
86. "Commercials"
87. I Spy
88. The Flintstones
89. The Odd Couple
 (Randall/Klugman)
90. Sanford & Son
91. Howdy Doody
92. My Favorite Martian
93. Our Miss Brooks
94. Red Skelton
95. Lone Ranger
96. Mister Rogers' Neighborhood
97. Batman
98. Dark Shadows
99. F-Troop
100. Highway Patrol

The Couch Potato Membership Poll of the All-Time Worst Television Programs

There is no such thing as a bad Television show.

COUCH POTATO™ Products

Couch Potato™ T-Shirts
(Viewing Tunics)

Yes, you'll make others look approvingly as you come into view when you wear one of these Official Couch Potato™ garments. Hand silk-screened on 100% cotton shirts. Model A, 2 colors. Models B & C, 4 colors. Available in S, M, L, XL, and XXL sizes.

$12.⁰⁰ ppd.
PLUS TAX

MODEL A

MODEL B

MODEL C

Sweatshirts

White, 50/50. Models B & C.
Only in sizes L & XL.

$22.⁰⁰ ppd.
PLUS TAX

Couch Tomato T-Shirts

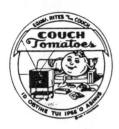

$12.00 ppd
PLUS TAX

Attention lady viewers! Here's the appropriate wearing apparel for any viewing occasion. Hand silk-screened in three colors on 100% cotton T-shirt. Available in MEN'S SIZES S, M, L, and XL.

Couch Potato™ Rabbit Ear Pennant

Attaches to your set's antenna. Alleged to improve reception. Gives your TV that mark of distinction.

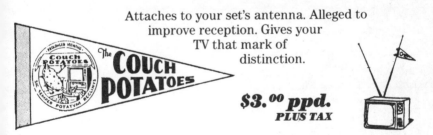

$3.00 ppd.
PLUS TAX

Special Thanks

To Allan (Chef Aldo) Dodge for his fine recipes, to Fred Dortort for finding the Blake TV poem and to Arlene LaBunche for the Hassock exercise.

To Stephen Williamson for risking his future in the generally anti-TV publishing business for editing this book.

To Kathy Loomans, Steve Michell, Diana Schutz and Peter Grubbs for their helpful comments and suggestions.

To Channels 2, 20, 26 and 44 in San Francisco for showing TV classics during the day

To Nuna James for keeping my TV set tuned while I worked on this book and to her cat, Zivili, for keeping it dusted.

To all the Pasadena men and women of the couch, who were the initial inspiration for this book.

VIEWER'S NOTES

VIEWER'S NOTES